COLOURING it FORWARD

DISCOVER BLACKFOOT NATION ART AND WISDOM

AN ABORIGINAL ART COLOURING BOOK

DIANA FROST

ISBN 978-0-9952852-0-0

Printed in Canada

For information about custom editions, special sales, please contact diana@colouringitforward.com.

www.colouringitforward.com

THIS BOOK BELONGS TO:

Table of Contents

Greetings to all my relations,

It is the Blackfoot tradition to begin each day by giving thanks for all that you have. I would like to introduce you to the Colouring It Forward project by first thanking you for purchasing this book.

As an artist and Algonquin Métis, I have always been drawn to the beautiful imagery and spirituality of Aboriginal art. For some time, I've wanted to learn more about my roots; to both explore more of the wisdom Indigenous people offer and to offer something in return.

This has led to the Colouring It Forward project. *Colouring It Forward – Discover Blackfoot Nation Art and Wisdom* is the first in a series of books, each focused on a different First Nation and its art and teachings.

For this first book in the series, I've had the privilege of working with Blackfoot Elder, Camille Pablo Russell to gather traditional wisdom, and with the incredibly talented Blackfoot artists, Kalum Teke Dan and Ryan Jason Allen Willert, all of whom have been very generous and giving of their time.

Inside this colouring book, you will find the Elder's teachings and the stunning images created by Kalum and Ryan, which have been recreated for you to add your own artistic touch. With each image is a place for you to journal as you colour. I would thrilled If you would like to share your art, your stories or ideas for new books or projects on my Facebook and Instagram pages – please link to these through my website at **www.colouringitforward.com**.

To honour the gifts I have received through this project, a portion of the proceeds of sales will go to the contributing artists and to any elders sharing their wisdom. A further portion of the proceeds will be invested in projects for First Nations people. These projects need to create opportunities for employment, improve small businesses or lead to higher education. Please contact me at diana@colouringitforward.com if you have an idea for new projects or a proposal for funding.

If you are interested in more information about the Colouring It Forward project or wish to purchase an original piece of art, please visit my website at www.colouringitforward.com.

Before you begin creating your own works of art, I want to share some Blackfoot history with you.

The Blackfoot Confederacy are also called the Blackfoot Nation or Siksikaitsitapi, which means 'Blackfoot-speaking real people'. The Blackfoot Nation includes three Aboriginal nations: the Kainai, the Piikani and the Siksika. Over 22,000 Blackfoot people live in Southern Alberta, Canada and in Montana, U.S.A., although their traditional territory also extended to the province of Saskatchewan in Canada. They were a nomadic people and a warrior people, following and hunting herds of buffalo which provided them with shelter, clothing and food. To the Blackfoot people, the buffalo represents the qualities of perseverance. The buffalo faces the storms of life and walks into them.

I invite you to follow the buffalo. We will walk into the storm together.

Meegwetch (translation - Thank you in the Algonquin language)

Diana Frost

Diana Frost

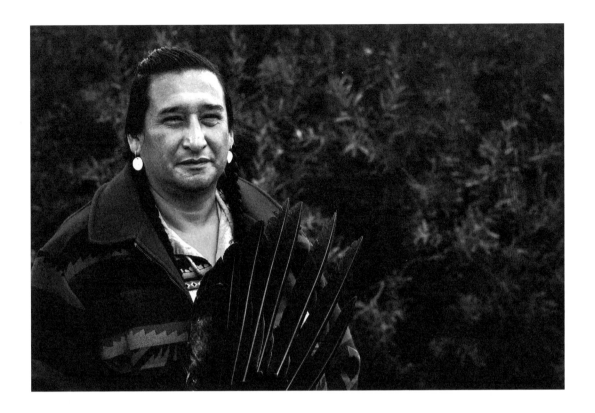

Camille Pablo Russell
(Shooting in the Air)

Camille Pablo Russell was born on the Blood Reserve in Southern Alberta. His Indian name is Shooting in the Air, and he goes by the name Pablo. He grew up being very close to his grandparents. It was through them he learned a lot about his roots and traditions.

Over the past 20 years, he has lectured in Europe on Mental Health, Coaching, Traditional Herbs and Leadership Management. His workshops are based on the principle of "Follow the Buffalo". For First Nations people, the buffalo represents the qualities of perseverance, facing the storms of life and walking into them.

Pablo also works in Calgary, Alberta at the Elbow River Healing Lodge as a spiritual counsellor.

For more information about Camille Pablo Russell, please visit **www.colouringitforward.com**.

Kalum Teke Dan

Kalum Teke Dan is a Blackfoot artist from Calgary who originates from the Blood Tribe in Southern Alberta. He was first inspired to create art by his grandparents, who were known internationally for their bead work and traditional regalia.

Mostly self-taught and working in both oil and watercolour, Kalum has become known for his strong portraiture and his stunning wildlife depictions. His portraits are based on real life people – those who portray the strength and the pride of the People as a whole. He captures the spirit of the animals he paints on canvas. His work is in the personal collection of several Canadian Premiers, international leaders and many of Canada's leading corporations. His work can be found in galleries across Canada and the United States.

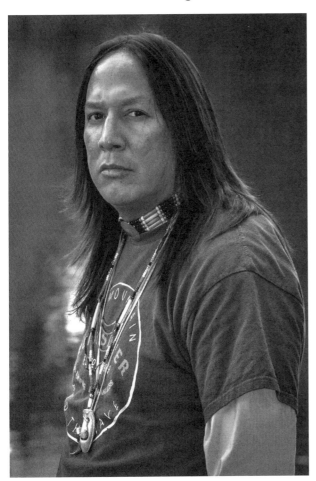

Kalum has also been commissioned to paint several murals of significant size by organizations in both Calgary and Edmonton.

For more information about Kalum or to purchase his art, please visit www.colouringitforward.com.

Ryan Jason Allen Willert

(Heavy Shield)

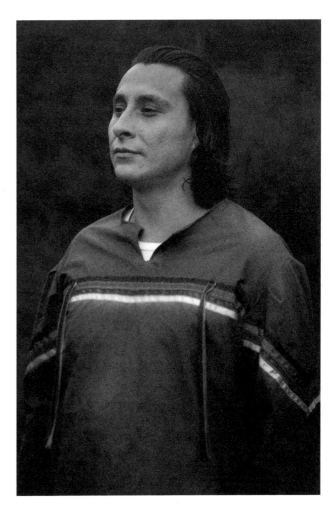

A full-time artist and storyteller living in Red Deer, Alberta, Ryan Willert was born and raised in Southern Alberta. Although he was brought up in a non-native community, he has since reconnected with his Blackfoot roots (Siksika Nation). Ryan learned the art of black ink drawing from his father Richard (Dicky) Stimson, another well-known Siksika Nation artist.

Awarded New Tribe Magazine 2010 Artist of the Year, Ryan has had many exhibitions including being showcased at the Glenbow Museum in 2009 and the City of Calgary during their 2007 Smoke Free Calgary campaign. Ryan has also done readings of his stories in front of large audiences including the Calgary's Aboriginal Awareness Week at Mount Royal College in 2008. He has spoken several times in front of youth and adult classes for life skills students through the Personal Support & Development Network and other special initiatives; including 2008's Future Aboriginal Business Leaders Symposium in Pincher Creek. Ryan is sought out as an important role model in the community, especially for youth outreach and inspiration. In September 2016, Ryan completed his first mural located in the Main Street of Mount Royal University (MRU). This is the first native themed mural painted for MRU.

For more information about Ryan or to purchase his art, please visit **www.colouringitforward.com.**

PEOPLE OF THE PLAINS

Plains people are buffalo hunters who live in tipis. Every day we begin the day by giving thanks to the Creator Apistotoke. Thanks for the good and the bad, thanks for our five senses and we ask for guidance, protection and strength. The eagle, the bear, the wolf and the buffalo are our guiding animal spirits. We move every three days so as not to damage the grass and our medicines because it isn't our land, it's our children's land.

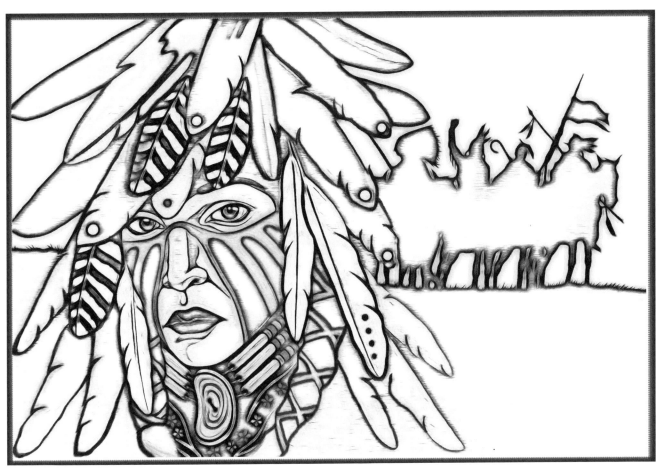

MEDICINE DREAMER

The snake tricked the Moon Ko'komiki'somma and so she bears no children. The Moon is the wife of Naato'si, the Sun. Together they are the parents of the stars and they watch over us.

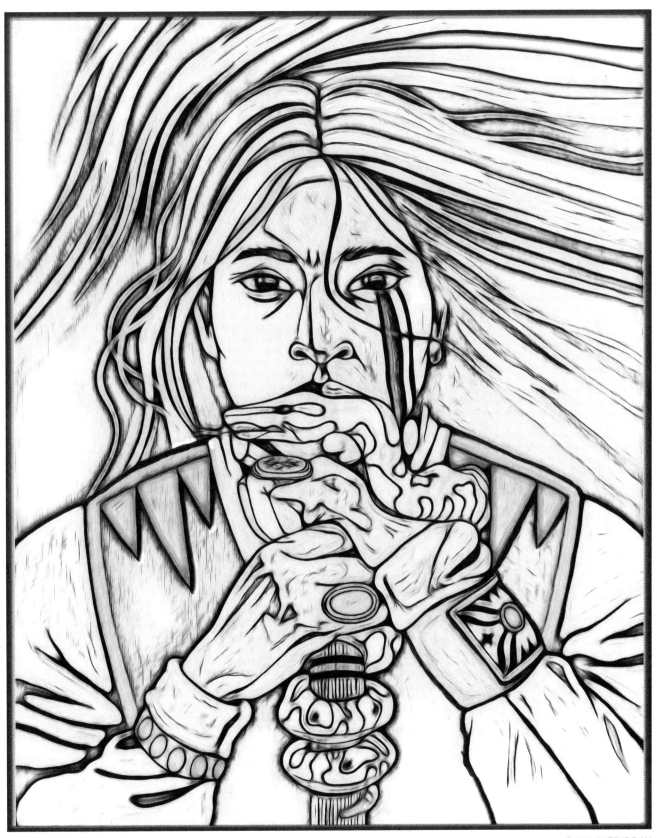

© KALUM TEKE DAN

17

MOONLIGHT SPIRITS

At night, the moon takes over for her husband the sun. We ask
for her to talk to the sun for us when we are asking for help.

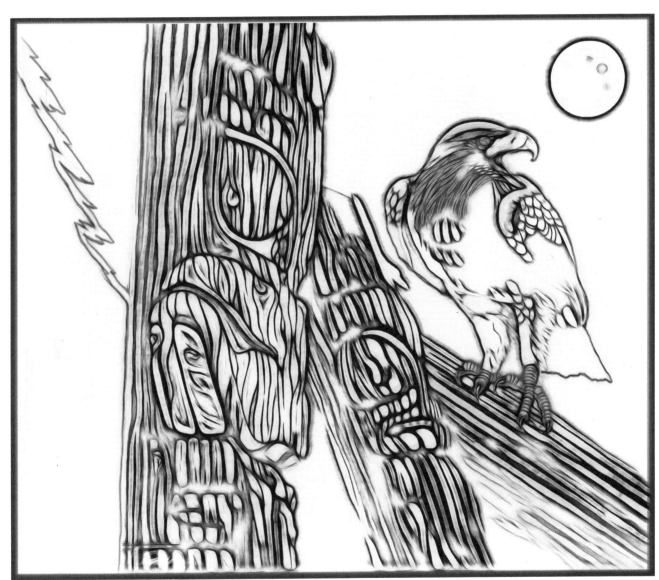

THREE FEATHERS

When the horse came, we joined our spirits' life. Tipis got bigger, we moved faster. No longer did we waste so many buffalo on the buffalo jump. Now we ride up to buffalo, now we ride into battle.

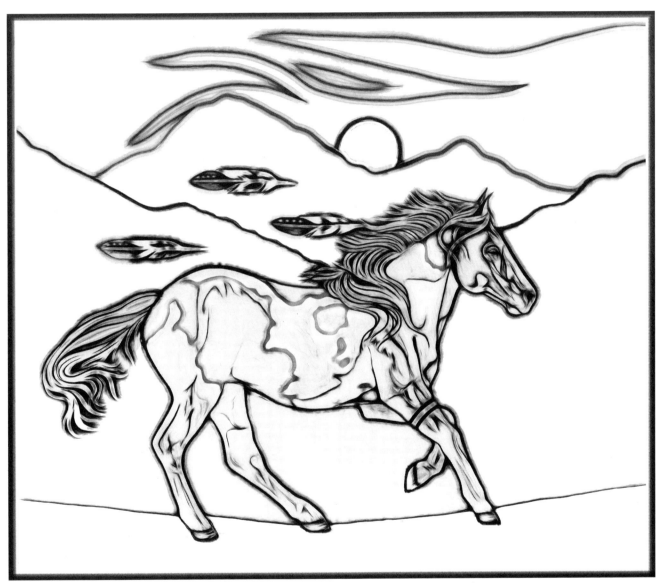

© KALUM TEKE DAN

RIVER GUIDE

"Life is like a river", said grandfather to his grandson, "I have crossed it. If you listen to me, I will tell you where it is shallow and you will never struggle for air. If you don't take my advice you will find the deep parts and struggle." If we listen and learn from our elders, we will struggle less in life.

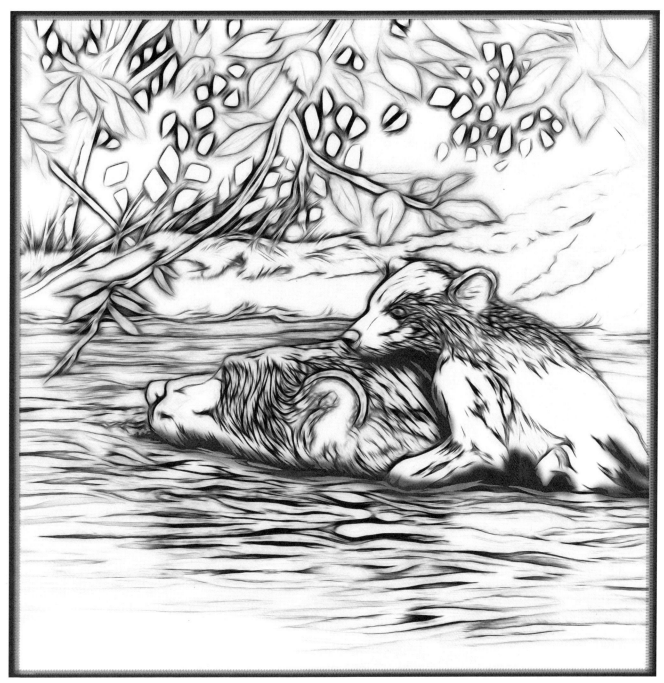

CULTURAL PRIDE

Be thankful and proud of your heritage. Set a good foundation so that when you fall you don't fall far and you are resilient to dance the dance of life the best that you can.

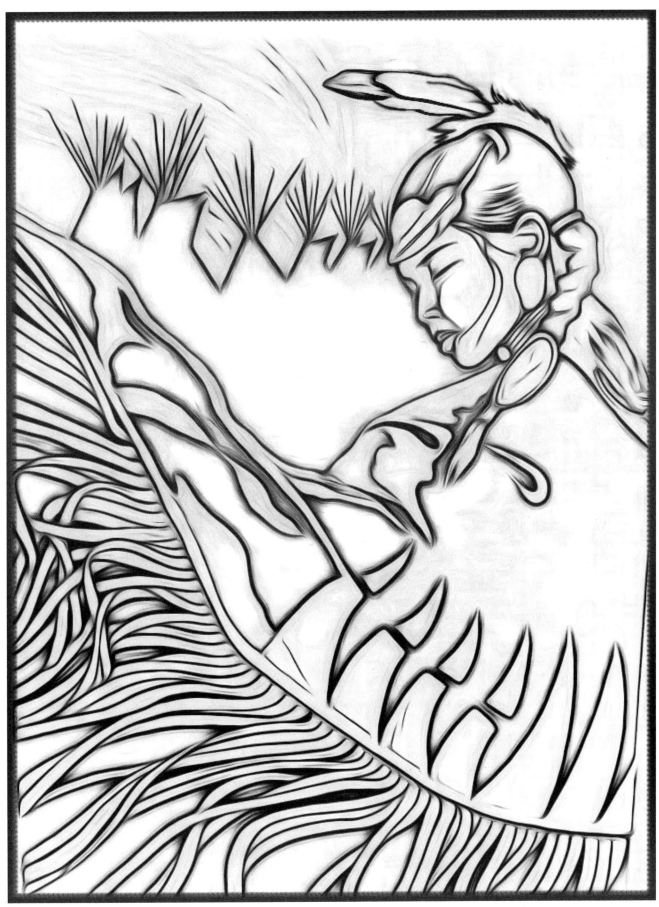

THE GUARDIANS

The wolf is a guardian. He taught us how to live in clans and how to hunt together as one. Wolves lead us on the wolf trail, which we also call the Milky Way. When we die, we follow the wolf trail to heaven.

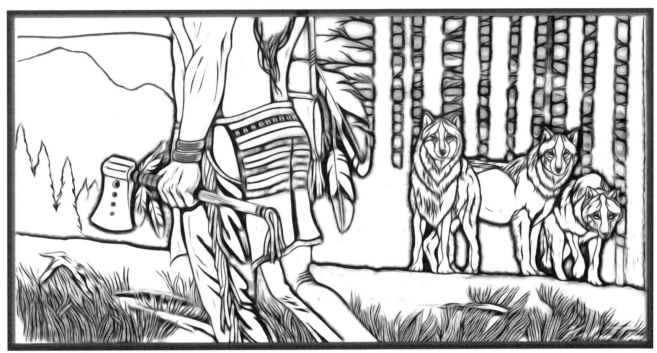

© KALUM TEKE DAN

BUTTERFLIES DREAM

In the back of tipis, a butterfly is painted to give the tipi owner good dreams to chase and catch. Butterflies enable us to practice being quick and then we release them.

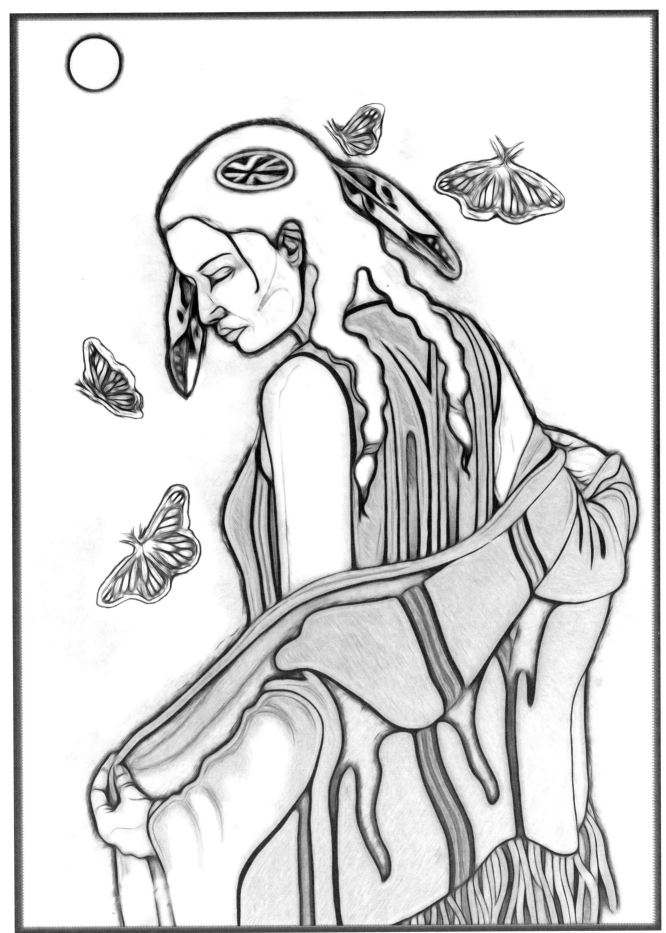

DREAM SPIRIT

If we are fortunate, we go on a vision quest and find our purpose in life. A vision quest involves fasting and praying for three days. During this quest, some animal may take pity on us and give us a gift such as a song or medicines.

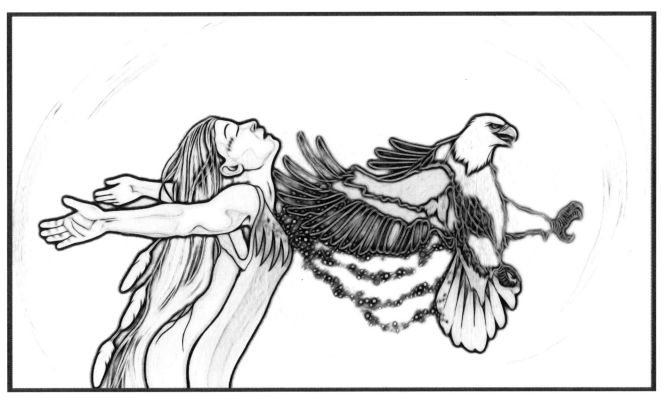

THE GIFT

Receiving a feather is a great honour. A person is gifted a feather because they achieve something great that will help people. Chiefs, warriors and braves received feathers for heroic and selfless acts – such as fighting bravely in battle, or defending people against animals, or when they became sundancers.

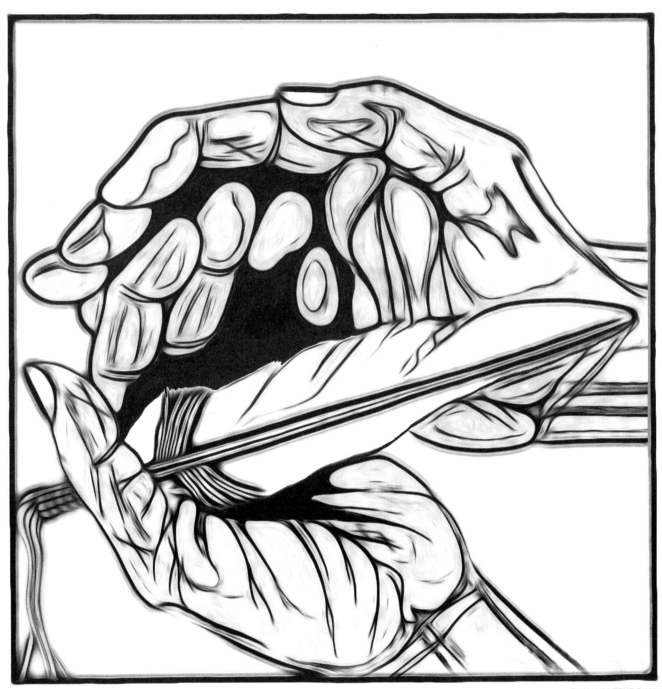

HORSE THIEF

We stole horses to become rich. To have horses meant wealth and gave us the ability to share them with others when moving camp or hunting.

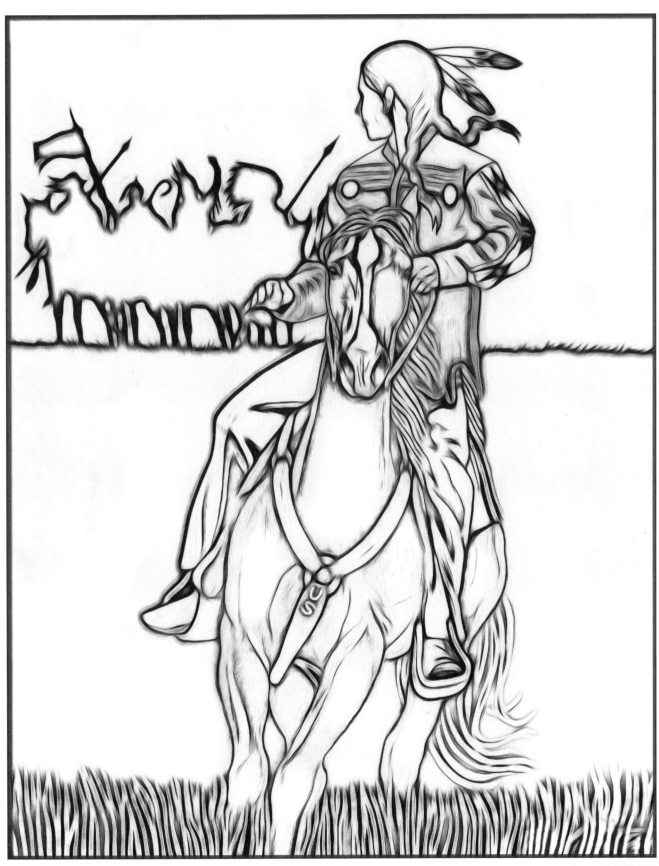

SUN DANCER

The Sun Dancer offers his body to the sun and suffers for whatever the sun touches – all plants, animals, water, rocks and all people. He asks for another chance for all mankind.

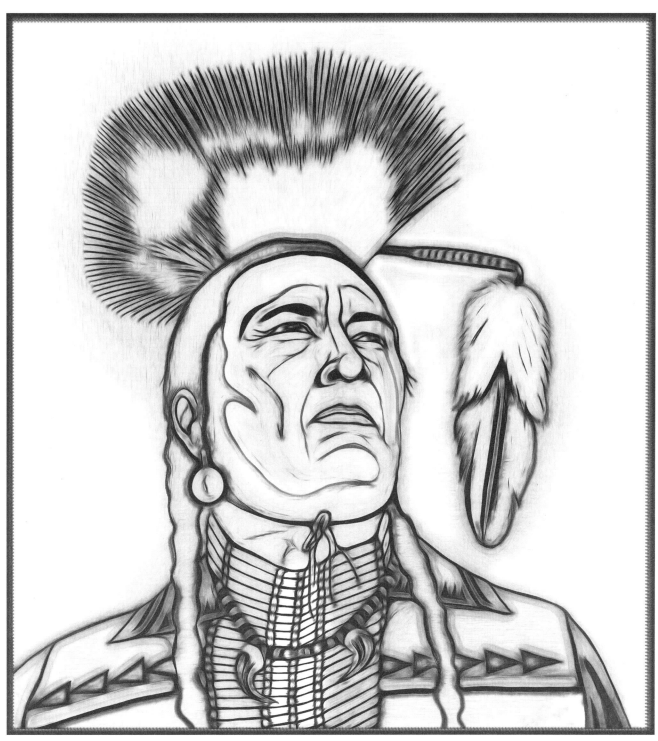

© KALUM TEKE DAN

SPIRITUAL ANATOMY

When you search for your animal spirit and your path in life, you go on a vision quest. During a ceremony you may get a vision which will allow you to visualize your dreams or receive a song to help you and others heal.

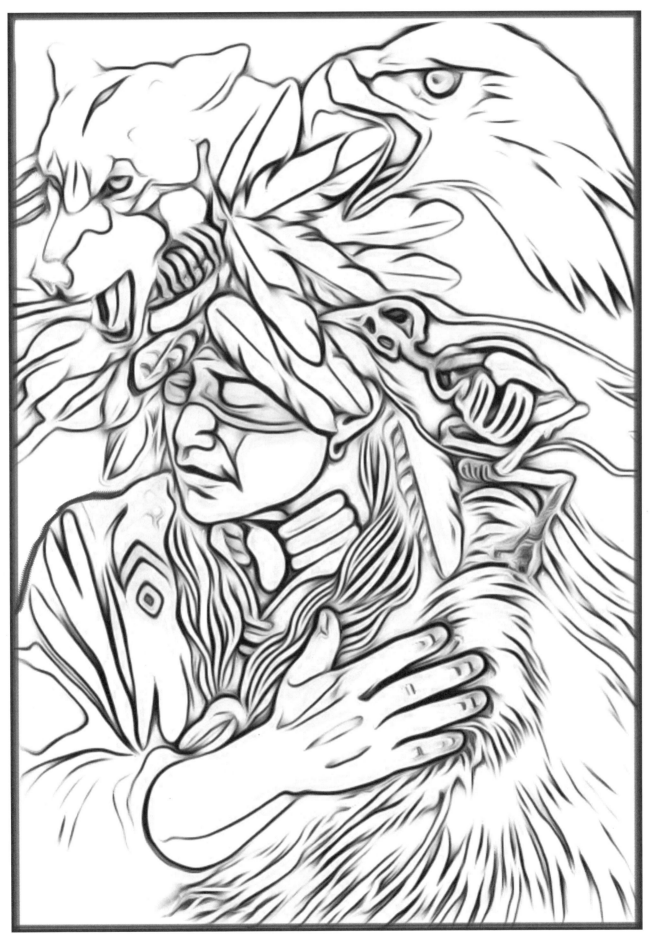

39

THE GAUNTLET

Obstacles are set in place to see if we mean what we say. They are placed in front of us to see if we give up or walk our talk. Don't get discouraged. Overcome these obstacles and your success will be of greater value.

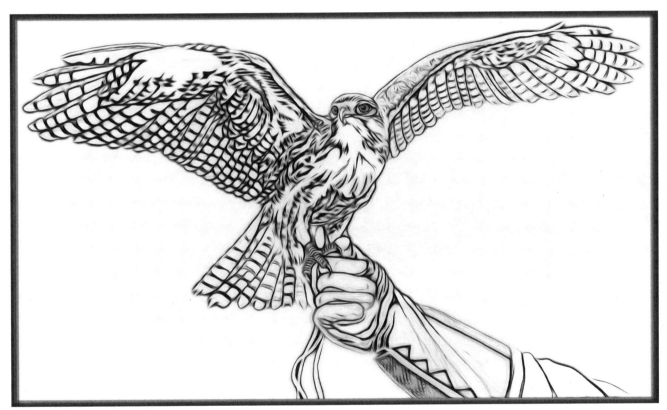

41

COURAGE

Be strong like the wolf and face your fears. Step into the unknown and don't be afraid to take ownership of your thoughts, actions and words.

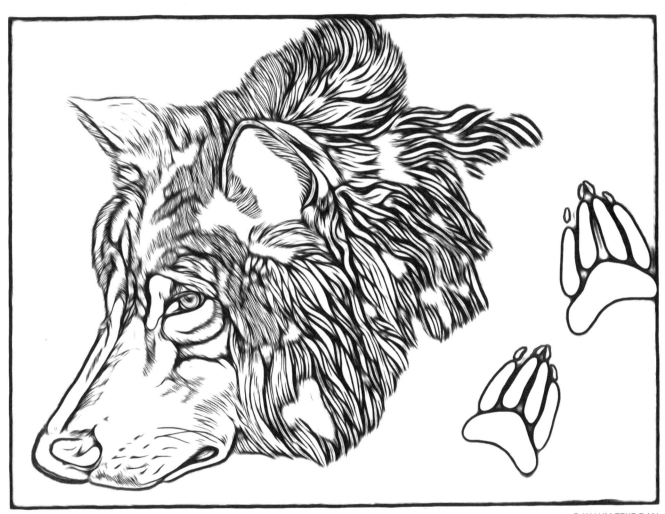

WAR HORSE

War horses were trained to kick the enemy and to dance to the beat of the war drums during battle. Loyal and faithful, the war horse carried its owner out of battle if wounded.

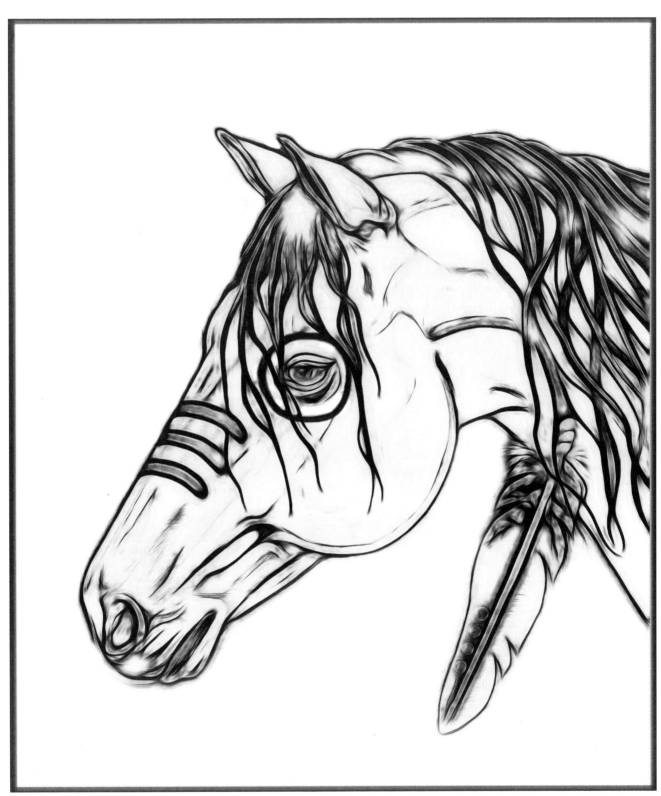

KEEP US WELL

The eagle represents strength and the importance of keeping the bond strong between all relationships such as families, couples or communities.

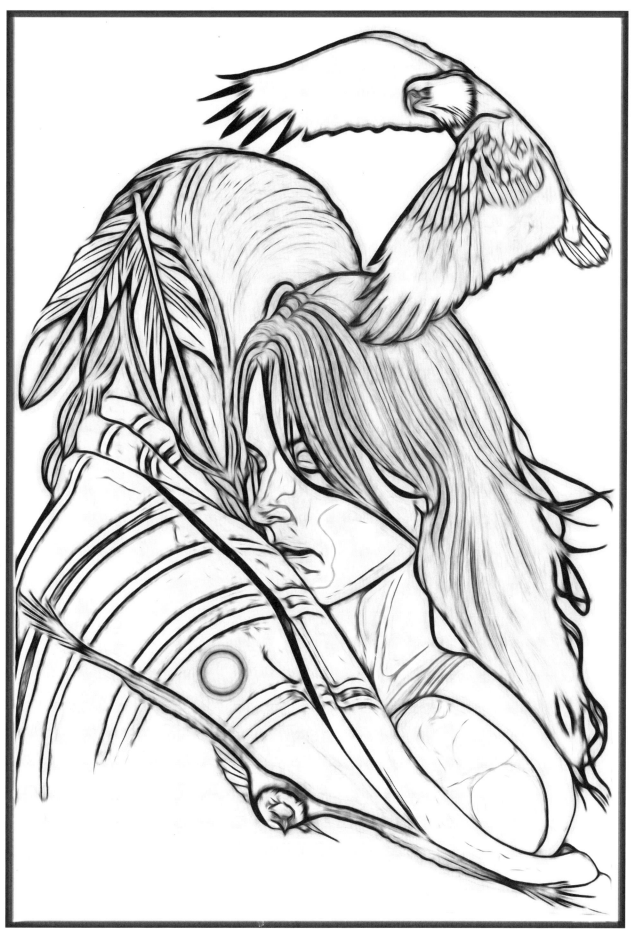

FIGHT FLIGHT

Eagles mate for life and hook their claws together to dance in the air. It looks like they are fighting but they are mating.

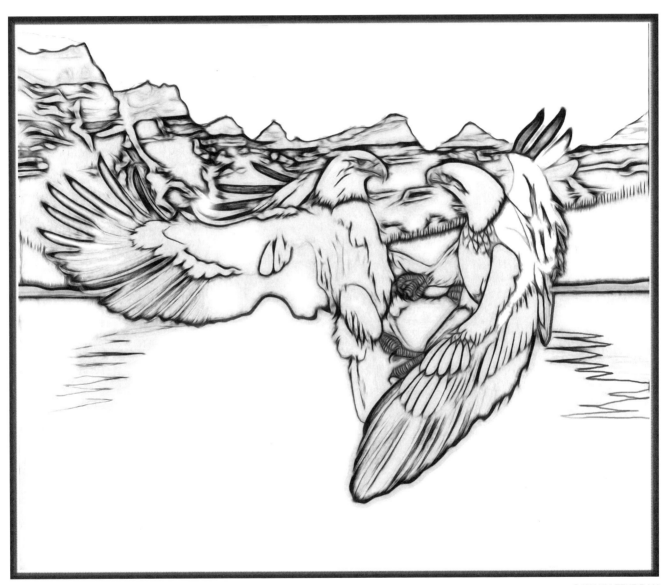

THE OFFERING

Energy is exchanged when you ask for something, so you give a gift. When we pick medicines such as sweetgrass or sage, we offer tobacco first. When we kill an animal during a hunt, we only take what is needed to ensure the next generation has some food. We teach this to our children. We give the best we have when we are asking for things. We cannot do without the Creator's help.

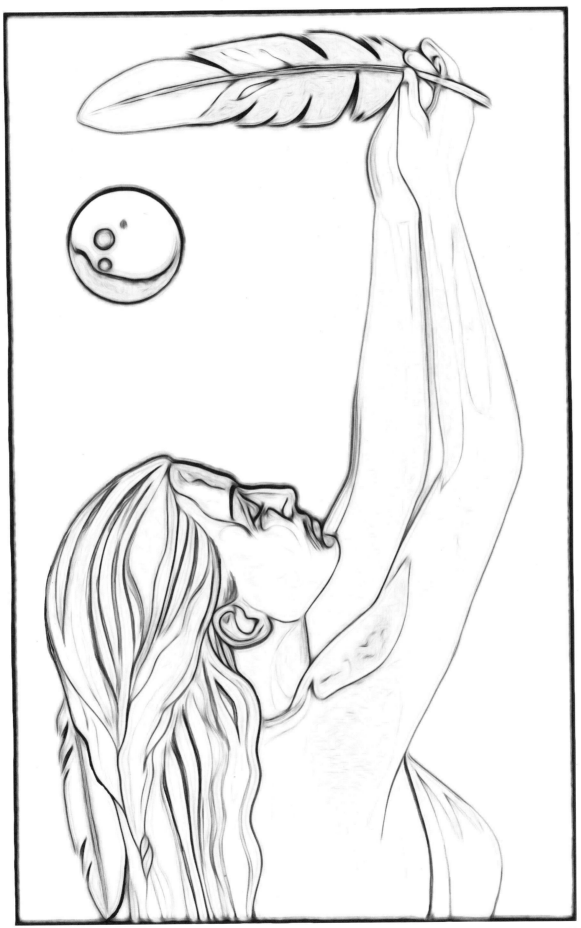

JOURNEY HOME

When we die, our spirits do not leave the world but travel to the sacred sand hills, an area south of the Saskatchewan River. There, all is happy and we meet with our relatives. We live there as we had in life and communicate with the living when they pass through the region.

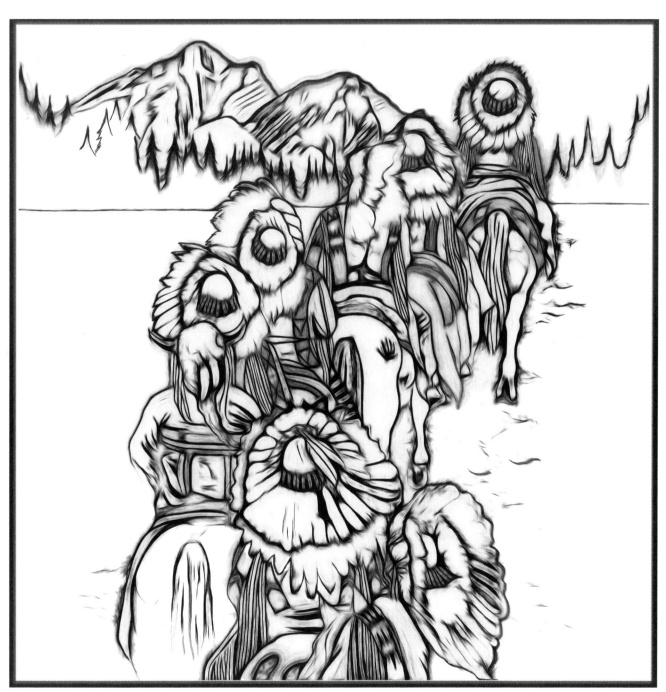

BLACK EAGLE

Black Eagle is an old eagle. Wise and strong, the old man carries our prayers and requests to the Creator.

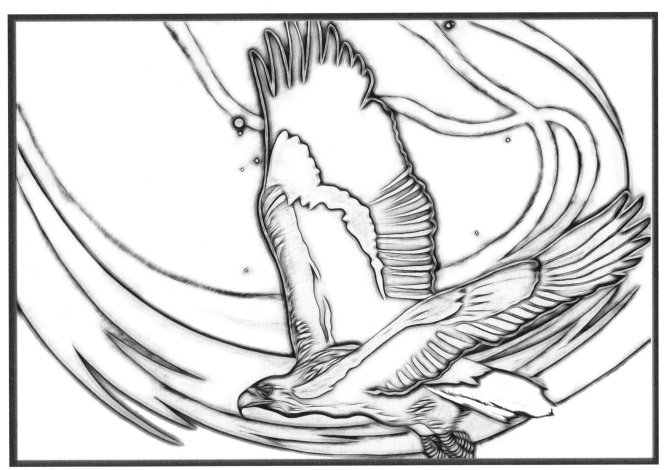

CHIEF SHOT ON BOTH SIDES

He led his people from the buffalo days into the reserve days. Well respected, he was part of all the ceremonies and keeper of the thunder pipe. His son was the last hereditary chief and was taught by his father how to be a chief, which means father of his people.

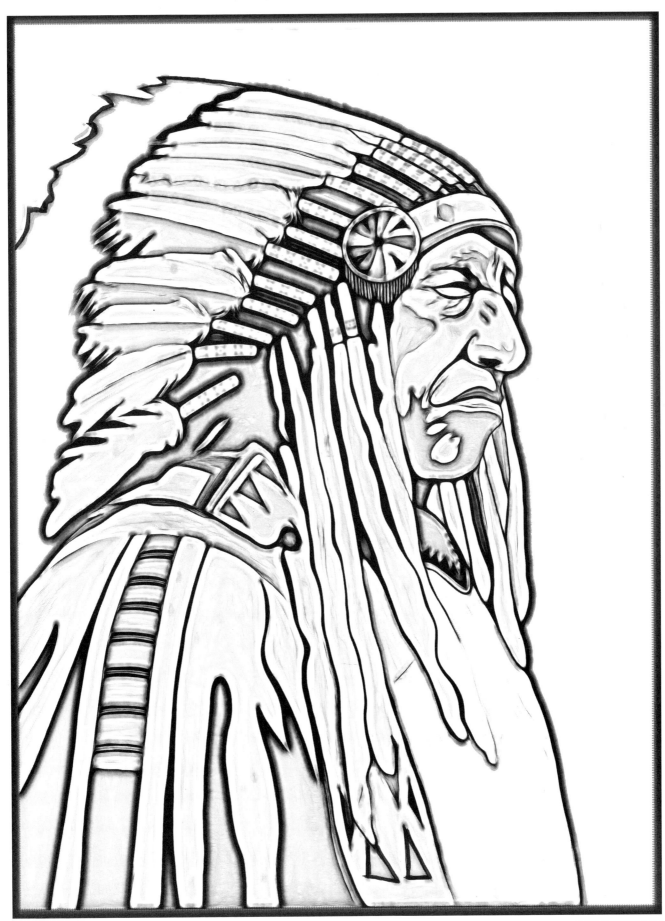

BONES OF OUR PAST

The bones represent the mountains and the rocks. They are the foundation of our existence. They keep us upright and straight. When we leave, all that is left is our bones.

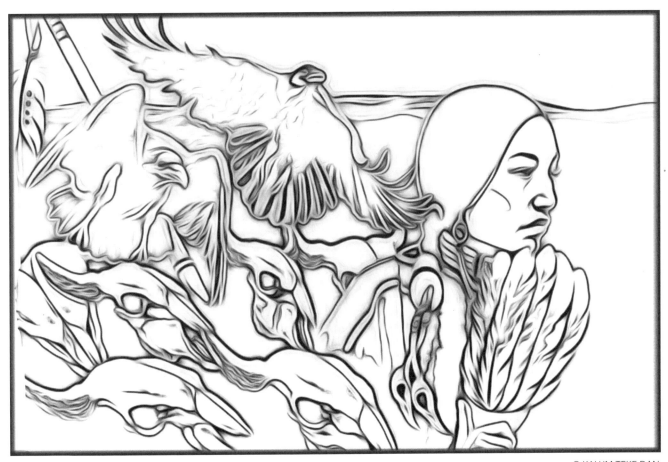

© KALUM TEKE DAN

SUNSET SONG

When the sun sets, we give thanks for what we received that day. If someone made us laugh or someone made us cry, we give thanks for the good and the bad. In a lifetime, we never know when we will be called home so giving thanks helps us prepare to move on.

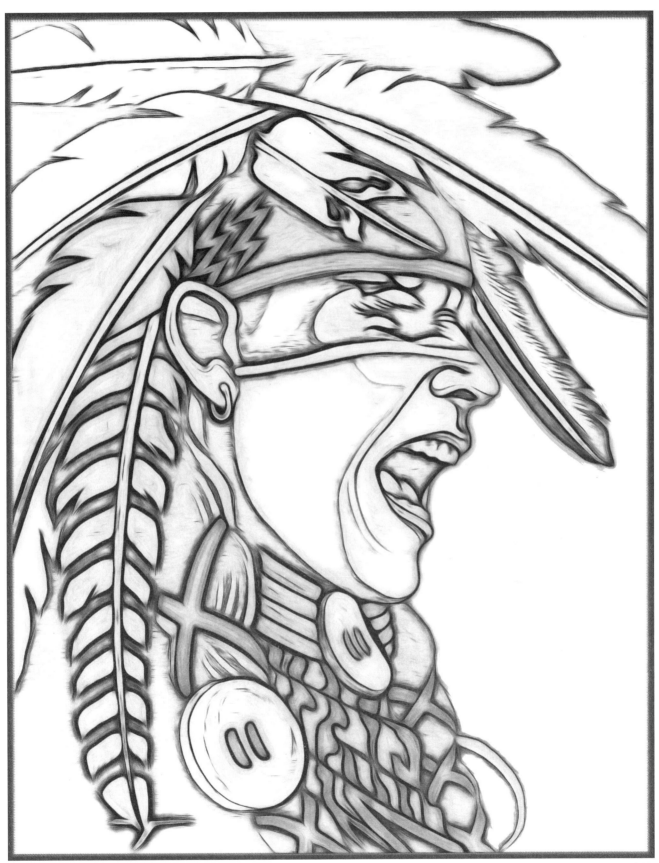

© KALUM TEKE DAN

WALKING INTO THE STORM

The Buffalo is the only animal that faces the storm. As First Nations, we follow the example of the Buffalo and we face the storms. We do not blame others for our mistakes. We own them and take responsibility.

At 40° below zero, an old man walked around the camp saying, "What example are you setting for my grandchildren by huddling by the fire? You men must go hunt. You women fetch wood and water." That night they had lots of meat, wood, water and they survived because they faced their storm.

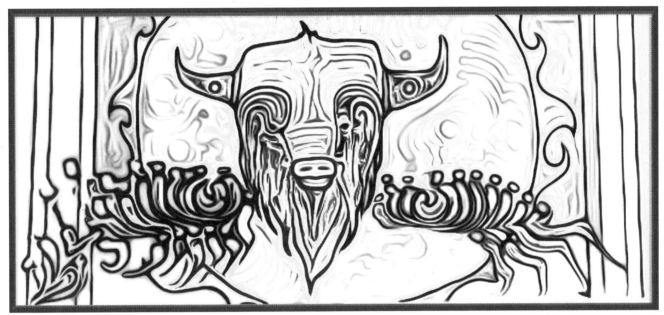

KNOW YOURSELF

Knowing where we come from will enable us to know where we're going, to know our clans, family and tribe. The roots consist of the language. All else falls into place when we know our language.

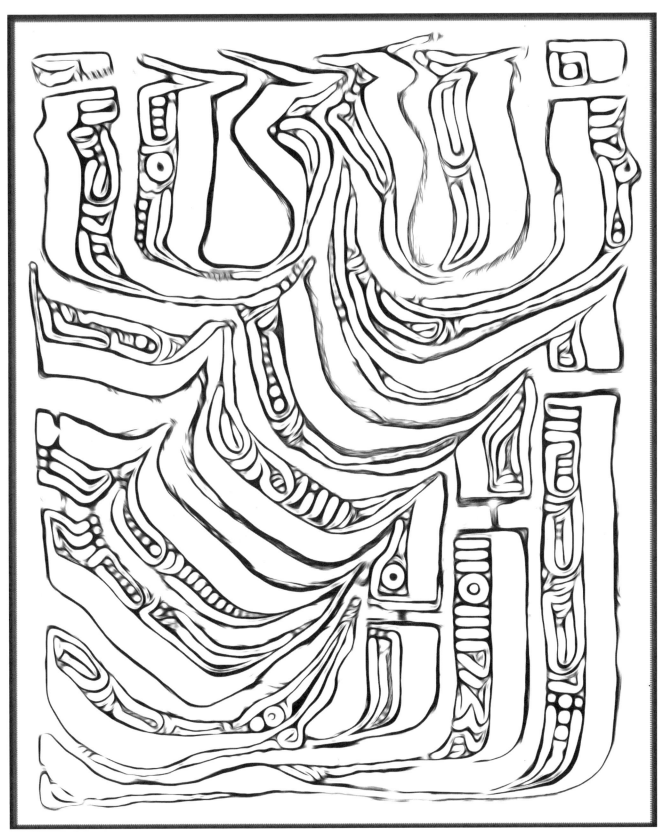

NATIVE ROOTS

Reconnecting with your roots allows you to be a strong person, to be brave, honest, and trustworthy. You can walk your talk, take ownership of your words and actions. Your thoughts are grounded and stable, you know where you come from and you know where you're going. You can leave a legacy to follow and can teach kids your way.

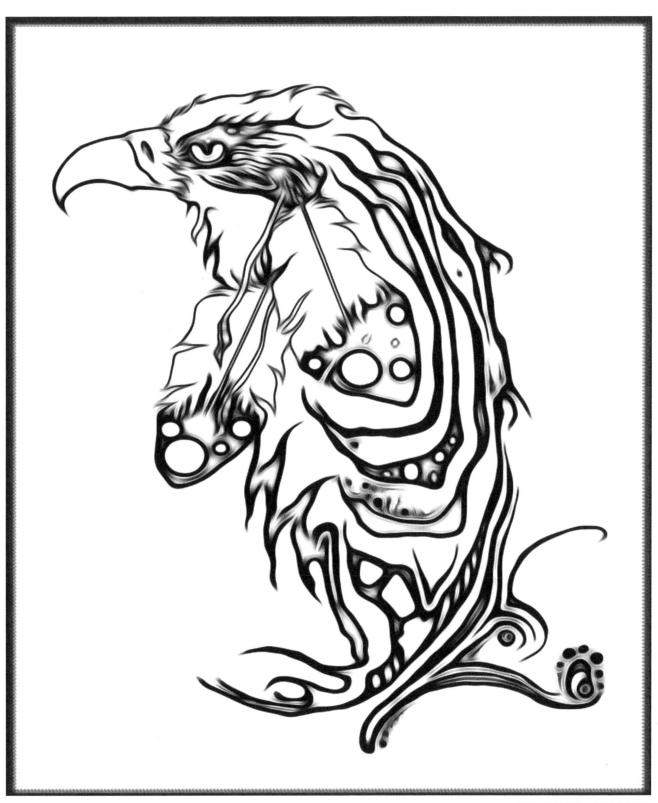

STRENGTH FOR WOMEN

Sweetgrass is a sacred medicine, which is usually braided and dried. It is burned at the beginning of a prayer or a ceremony, called smudging, to attract positive energies and purify a person or a place. It symbolizes healing, peace and spirituality. Smoking a pipe is done during sacred ceremonies – the smoke carries the prayers to the creator. Traditionally Blackfoot women are nurturers, healers and providers for the people.

The Eagle, the Bear, the Buffalo and the Deer will bring strength back into the homes.

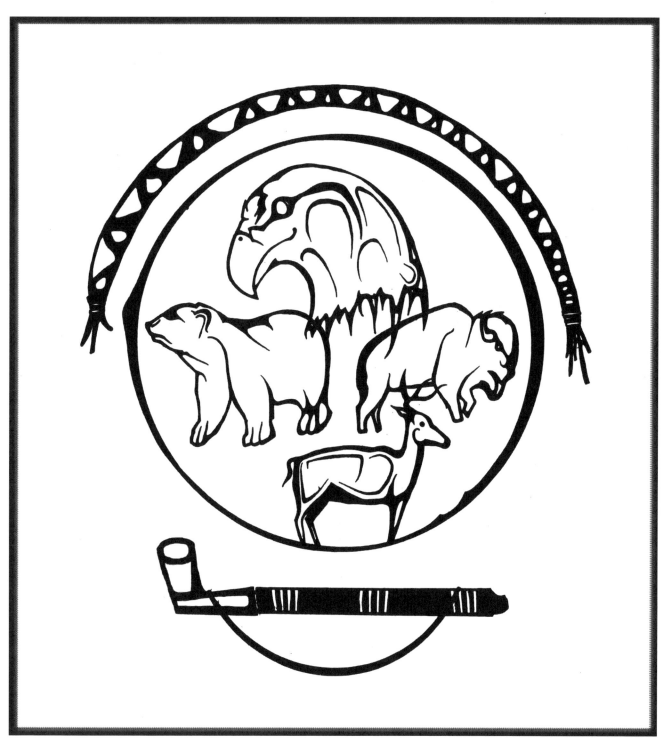

SACRED HEALING

We purify ourselves and ask for healing by going to healing ceremonies such as a sweat lodge, which symbolizes Mother Earth. When we enter the lodge, it is as if we re-enter the womb. It is dark and warm and we can reconnect with Mother Earth and with our grandfathers and grandmothers. We offer five stones in the first round to call the grandfather and grandmother spirits into the lodge to be with us. In the second round, we pray for ourselves, our families and we ask the grandfathers and grandmothers to help us. In the third round, we heal and ask for others to be healed. In the fourth round, we give thanks to the Creator and to the grandmothers and grandfathers for everything we have, for our five senses, for the good and the bad. At the end, we smoke ceremonial pipes to carry our prayers to the Creator. The sweat lodge helps us to heal the physical, emotional, mental and spiritual parts of our wheel.

MEDICINE WHEEL

Medicine wheels are used to explain a philosophy or way of life. There is not one true medicine wheel. There are many different teachings and many different types of wheels. Some wheels have colors in them, seasons, animals or directions, always in numbers of four.

We each also have our own medicine wheel. We all have four parts that make us who we are: the spiritual, emotional, physical and mental parts. All four parts need to have attention. When there is more attention in some parts than the others, then you are not centered and things will not go the way they should in your life.

How much energy do you devote to each part of your medicine wheel?

SPIRITUAL STRENGTH – CHAIN OF PRAYERS

When you look at your medicine wheel, if you feel the need to strengthen your spiritual part, you can do that by talking to the Creator. When you talk to the Creator, ask for things and give thanks for the good things and the bad things. The Creator is part of you and not to be feared.

Through developing this spiritual part, you develop the ability to forgive yourself and forgive others. Forgiveness will allow you to build better relationships. There are three steps to reaching true forgiveness. First you have to understand the story behind the situation. What led that person to act that way that upset you? What happened to them to make them into the person they are? Once you understand why they did what they did, then the next step is to accept them just as they are and with what they have, and not to be resentful.

What follows is true forgiveness from the head and the heart. Begin this process by accepting and forgiving yourself.

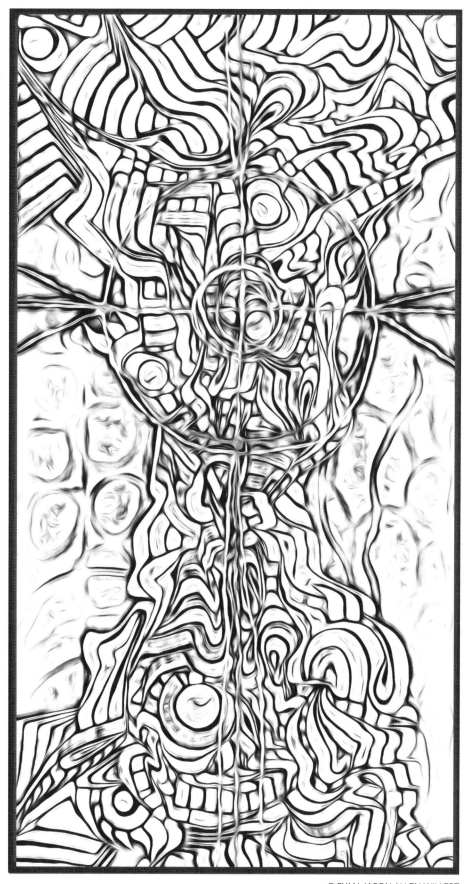

© RYAN JASON ALLEN WILLERT

MENTAL STRENGTH

We all have two egos: the positive ego and the negative ego. Our positive ego tells us: you are good, you can do it, the cup is half full, you are confident, you can fix this and you can make it. The negative ego tells us: poor me, do it for me, take care of me, help me, pity me, and feel sorry for me.

Which ego is speaking more to you?

To strengthen your mental part, you need to cultivate unconditional love and humbleness – you need to accept yourself with the good and the bad. You need to suppress your ego so that you are teachable and are able to listen.

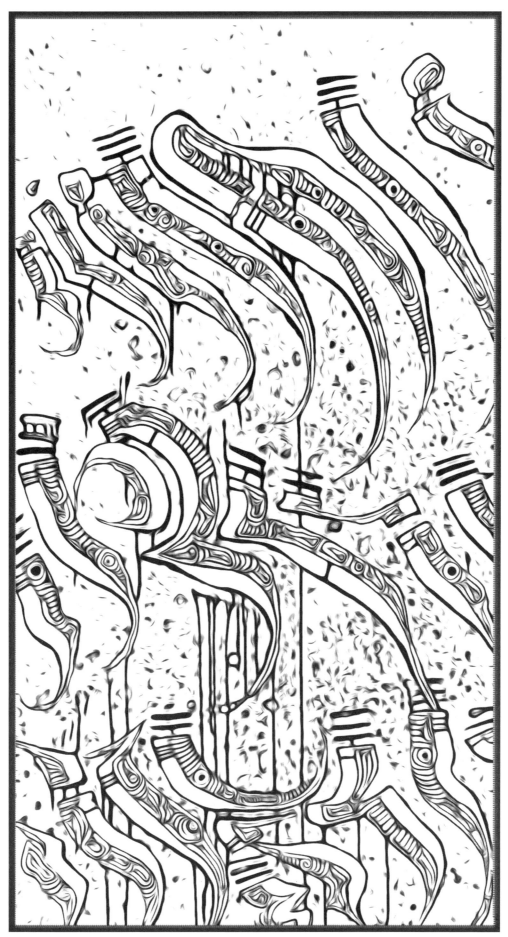

EMOTIONAL STRENGTH

Can you express your feelings? Do you know why you're crying? Can you say I love you? Can you hug people?

If you have a hard time expressing your feelings, hugging and accepting or giving love, you can do something about it. You can open your heart by learning to love yourself unconditionally and forgiving yourself. Then you can practice expressing yourself with other people or learn from people who have that strength. Open your heart and you will have a happier and more peaceful life.

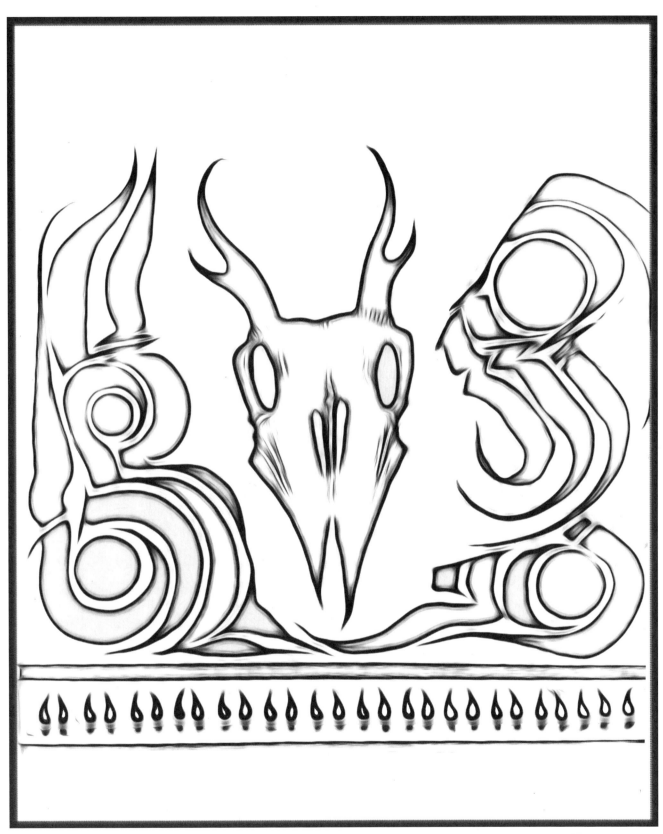

PHYSICAL STRENGTH – THE CRANE BEAR

The Whooping Crane and the Grizzly Bear are looking over our Mother Earth. We need to protect Mother Earth, and Father Sky and all its inhabitants – animals, rocks, people, water and air.

Your physical body is the image of Mother Earth. You need to protect it too as it is a shell for your soul. To strengthen your shell or the physical part of your wheel, you need to watch what you eat, exercise and take care of your body. Only then can your body help you to fulfill your purpose in life.

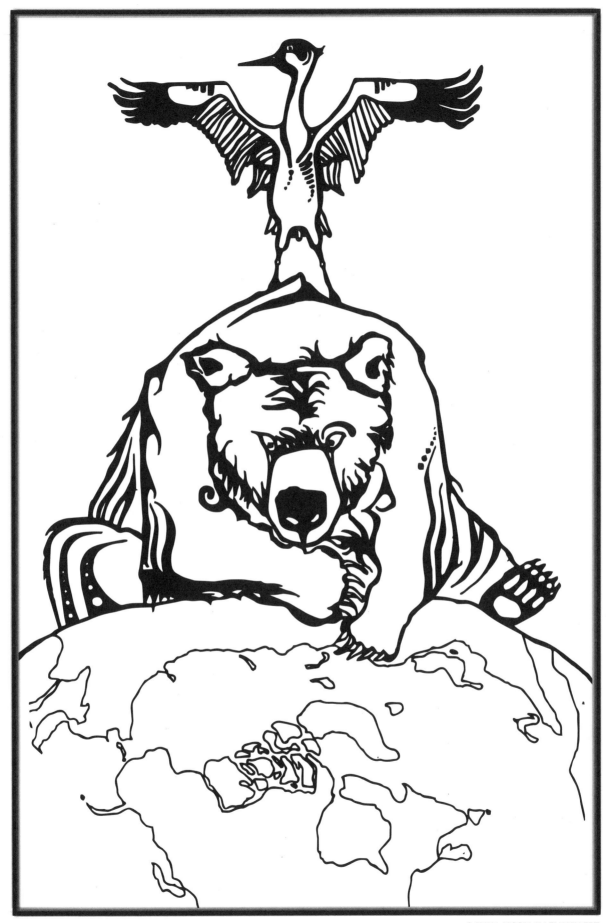

SPIRIT OF THE BIRD

All birds are sacred. They give us many gifts: songs, feathers and whistles for healing, and fans to cool us off in the hot summer. They give us feathers to help us make arrows go straight so that we can hunt and survive. Their feathers are also used for headdresses to make chiefs, and as recognition of achievements such as after a vision quest.

Feathers are a symbol of status. Not everyone can wear feathers. You need to earn them.

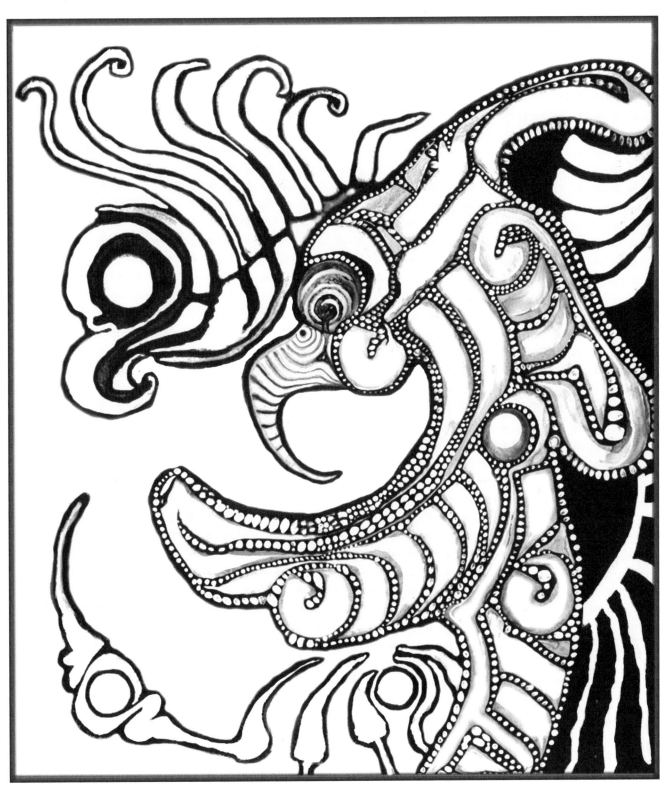

BEAR SIGNS

The Bear is the keeper of herbs and the healer of bones.

A man was surrounded by the enemy. He made a vow to the Creator that he would sundance if the Sun helps him. He ran into the bush and Bear was there. He asked Bear to help him and Bear let him into his den. They fought the enemy and Bear brought the man home safely. Bear smoked the pipe with the man and made peace. Blackfoot do not hunt Bear and Bear does not kill Blackfoot.

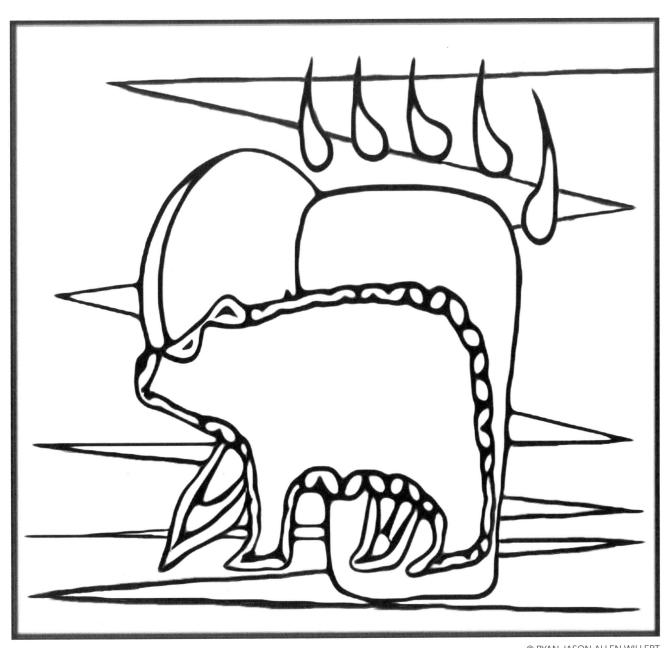

SPIRIT OF THE SPIDER

A man had the power of the Spider. He had a piece of leather tied in his hair. A boy was sick so the man took the leather out, put it on the ground and put grass on it. He said if it comes alive, the boy will live.

He sang his song. The piece of leather turned into a Spider and ran to the boy. Then it then crawled under the grass again and turned back into the leather. The boy lived and was given the name Spider. He became a great dancer.

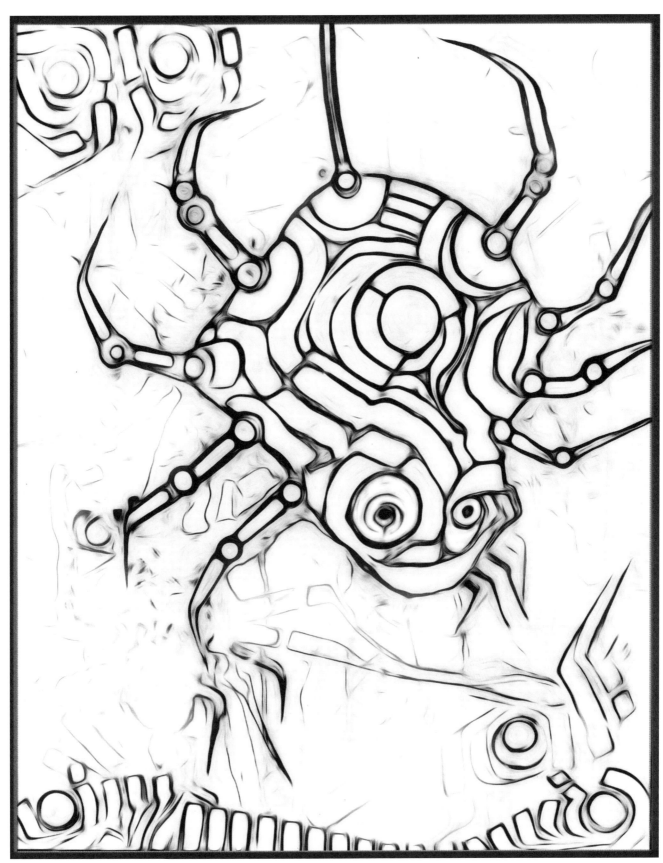

THE OTTER

Otter lives both on land and water. Otter does not dwell in the past or the future. He lives in the present and enjoys life by just flowing with it. Be like Otter and enjoy your life.

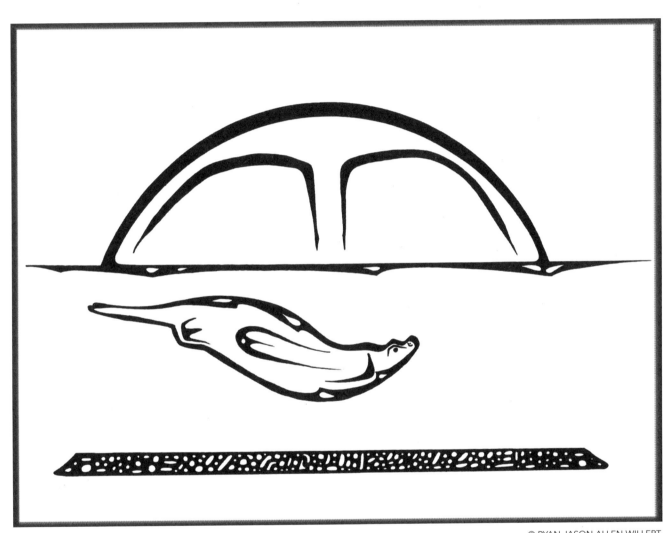

LIFE CYCLE

Above the fish is Ko'komiki'somma, the Moon and Naato'si, the Sun, ruler of the Sky People. Naato'si is married to Ko'komiki'somma and their son is Iipisowaahs, the Morning Star. They take turns caring for all Creation. Below the fish is Mother Earth and Bear. As with all Creation, the fish goes through many changes during its cycle of life.

Embrace your changes.

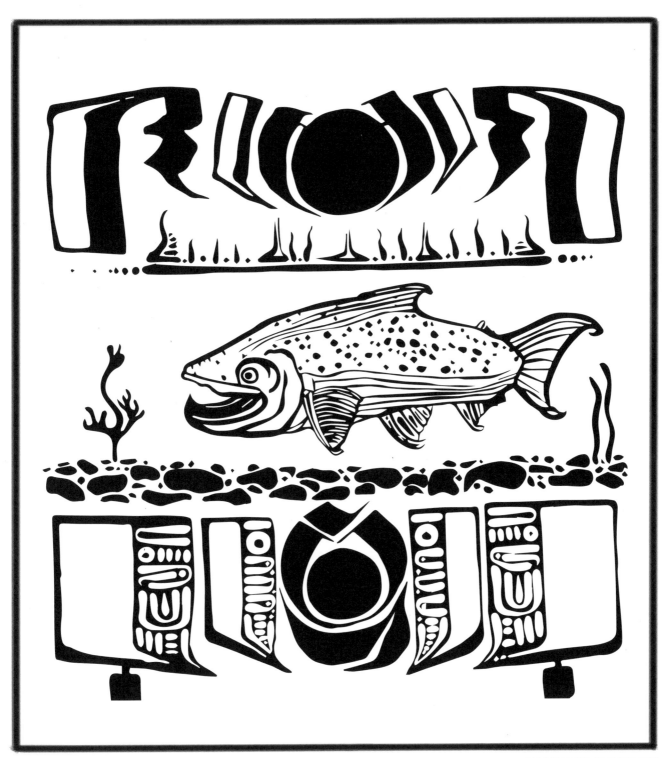

SPIRIT OF THE TURTLE

The turtle goes forward with determination and serenity. If you are overwhelmed, slow down and ground yourself. Be inspired by the turtle to be patient in your search for peace and be serene through the sometimes turbulent waters of life.

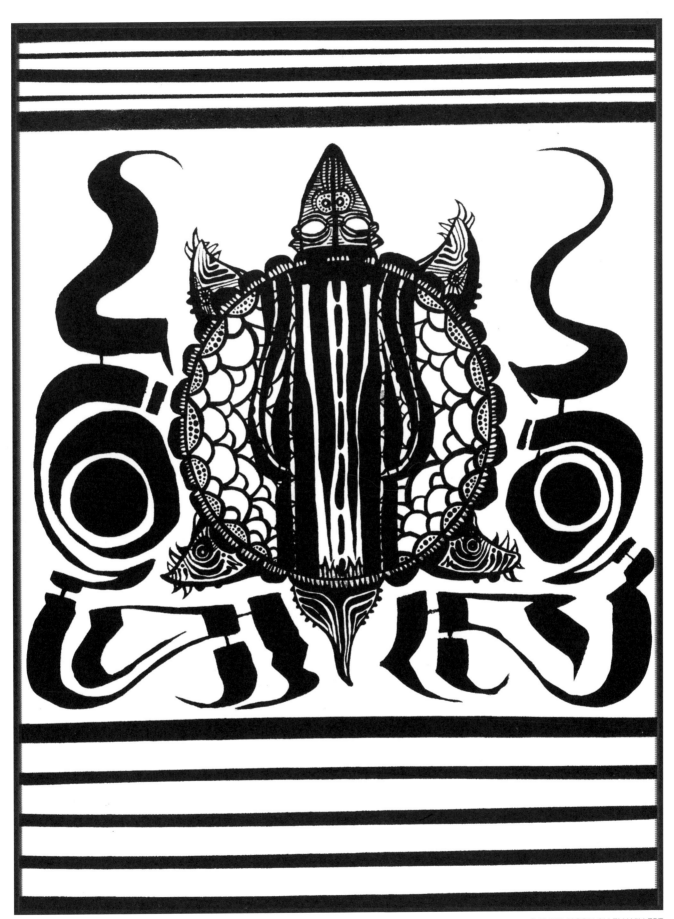

TRIBAL WAYS

Birds love to sing. Singing is something that is lacking in the world today. When you sing, you connect to your spirit, to your soul, to your heart, to your mind, to the center of the earth and out to the universe. Let us hear your song!

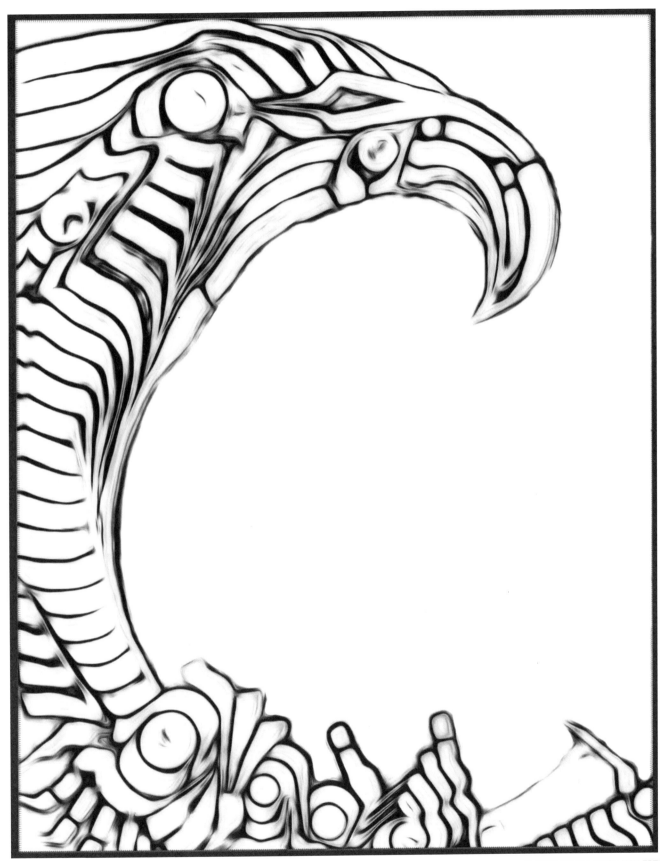

SPIRIT OF THE BUTTERFLY

Living for the moment allows your mind and heart to shake hands and agree. You are more aware of life, its importance and its beauty. You are more aware of yourself and happier. You feel more lighthearted, like a butterfly.

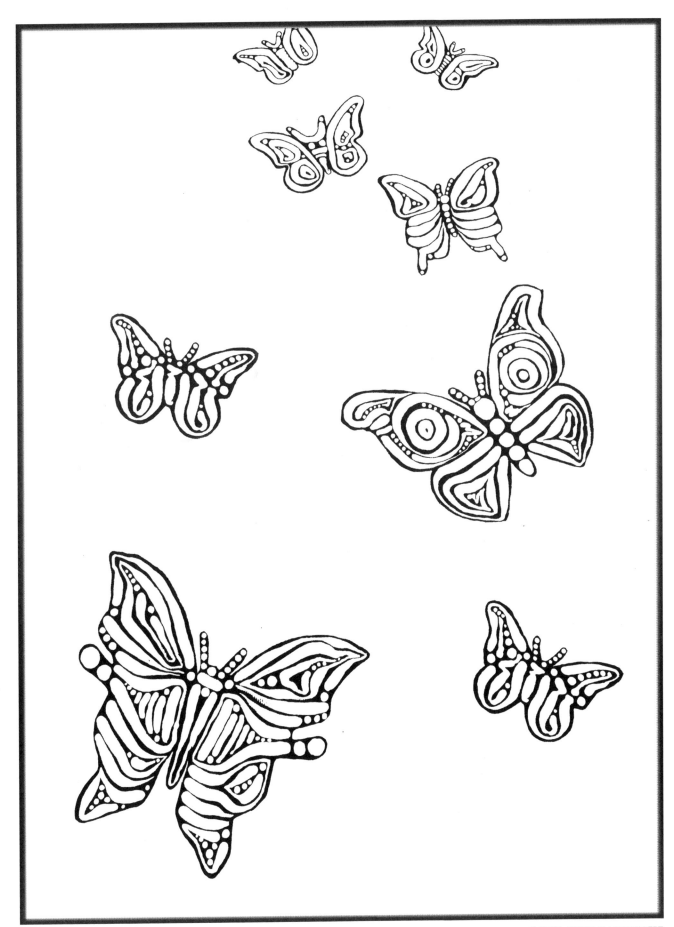

MOTHER EARTH

This picture represents Mother Earth with the spirits, plants and animals all flowing together. We are all connected to our great Mother. We are all connected to each other.

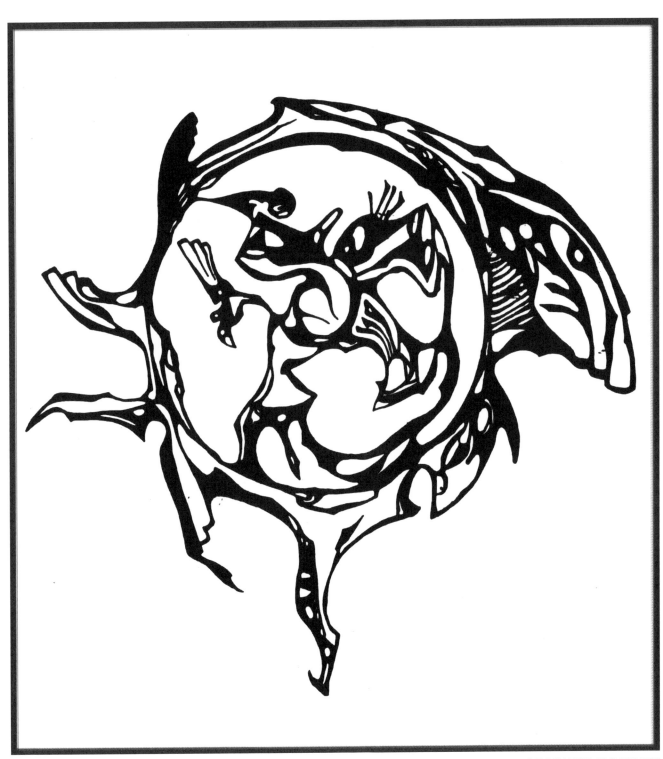

THE VOICE OF OUR ELDERS

To learn how to lead a healthy life and fix our medicine wheels, we need to listen to the oral teachings of our elders. The information we obtain today is from books and television. Our elders have lost a very important role in our society and we are losing our connection to our ancestors and to their wisdom.

Let's give them back their voice and listen to their teachings!

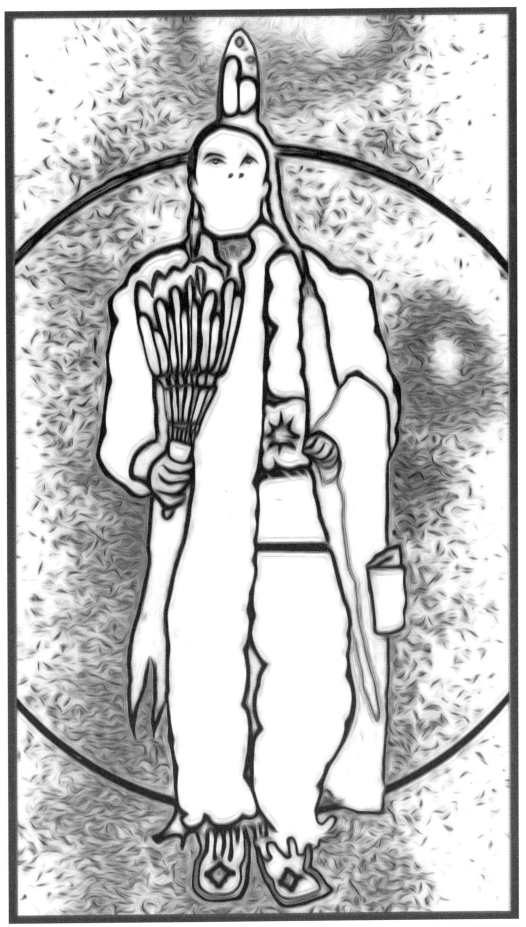

101

Thank you to my wonderful team for all their help with creating this book:

- Camille Pablo Russell for offering his teachings and stories that reflect Blackfoot spirituality and culture.
- Kalum Teke Dan and Ryan Jason Allen Willert for sharing their beautiful artwork.
- Cecilia Humphrey of Creative Capture for all her incredible graphic design work.
- Denise Summers of Amphora Communications for editing, promoting and marketing the book and helping me with so many other aspects of the project.

I couldn't have done it without all of you!

Thanks from the bottom of my heart.

~ Diana